100% EVIL

Published by
Princeton Architectural Press
37 East Seventh Street
New York, New York 10003

For a free catalog of books, call 1.800.722.6657.
Visit our web site at www.papress.com.

Editing: Clare Jacobson
Special thanks to: Nettie Aljian, Nicola Bednarek, Janet Behning,
Megan Carey, Penny (Yuen Pik) Chu, Russell Fernandez, Jan Haux,
John King, Mark Lamster, Nancy Eklund Later, Linda Lee, Katharine
Myers, Jane Sheinman, Scott Tennent, Jennifer Thompson, Joseph
Weston, and Deb Wood of Princeton Architectural Press
—Kevin C. Lippert, publisher

Library of Congress Cataloging-in-Publication Data
Blechman, Nicholas.
100% evil / Nicholas Blechman and Christoph Niemann ;
introduction by Chip Kidd.
p. cm.
ISBN 1-56898-526-6 (alk. paper)
1. Good and evil in art. I. Title: 100 percent evil. II. Title: One
hundred percent evil. III. Niemann, Christoph. IV. Title.
N8012.G66B48 2005
743'.9917—dc22 2004022090

"Woe unto them that call evil good, and good evil."

ISAIAH 5:20

100% EVIL

NICHOLAS BLECHMAN & CHRISTOPH NIEMANN

Introduction by CHIP KIDD

PRINCETON ARCHITECTURAL PRESS, NEW YORK

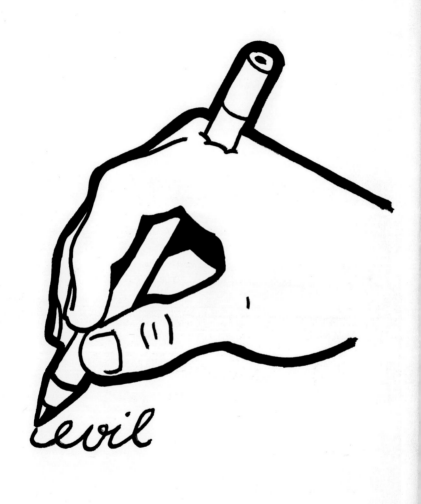

INTRODUCTION

I KNOW IT ISN'T FAIR, but some time ago I came up with an all-purpose response to that question of questions that we are faced with so often that we've come to forget or overlook what we're really being asked. You know the one. It's usually raised when you're in a group, and someone with some sort of petty authority—say a waiter or a tour guide or a stewardess—is presiding. This person is talking to you all, explaining something—the daily specials, how we'll all meet back here at the bus in forty-five minutes, that you can't use the bathroom while we're taxiing—and at some point they finally stop. And then they ask it: "Does anyone have any questions?"

Now, if I am part of this group and feeling especially put-upon by this person or otherwise disruptive, I will raise my hand.

"Yes?" they will inevitably ask.

And I will say it: "Um, why does evil exist?"

And, wow, that really throws them for a loop.

"Um…"

Like I said, it isn't fair. Fish in a barrel, really. But they asked, and I'm asking.

"Uh, what do you mean?" They always say that, too.

"Skip it."

It's certainly a straightforward enough question, the meaning all too clear to me. What about it is ambiguous? Of course the problem is the context, but the intent is sincere—I really want to know. Now, if I brought it down to a more specific, personal level, it might be more comprehensible: "Have you ever cheated

on your spouse, abused a child, lied on your tax return, stolen a car, robbed a convenience store, smothered a relative, mixed plaids?" Maybe that would make the question easier to answer.

But, allow me the cliché, let's look at the bigger picture. I don't have an answer, but I have drawn the possible conclusion that truly evil people don't believe that they're evil at all. Whether they are murdering Russian school children or invading a Middle Eastern country or condemning an entire race of people or using Enron as their bitch or commanding a mass of stupid "believers" to stop using condoms, they are convinced they're all doing it for some greater good. Despite the outcome of wrongful death and misery.

And the good people—they're the ones who are usually made to accept that they're evil. If you don't believe me, consider the plight of the Catholics at the confessional, Baptists in the Revival tent, Jews at Yom Kippur, and countless others who are all meant to think of themselves as sinners, atoners, unworthies, self-flagellants. And why? Only because they believe it.

And it's not natural. Nature doesn't have any sense of evil. There's nothing evil about a village being destroyed in a volcano. There's everything evil about a village being destroyed in a firebombing. Evil involves forethought. It's all in the planning.

Anyway, next time you're seated between a waiter and a tour guide on a plane and the stewardess asks if there are any questions, you might as well ask mine. Who knows, you may just finally get an answer.

CHIP KIDD

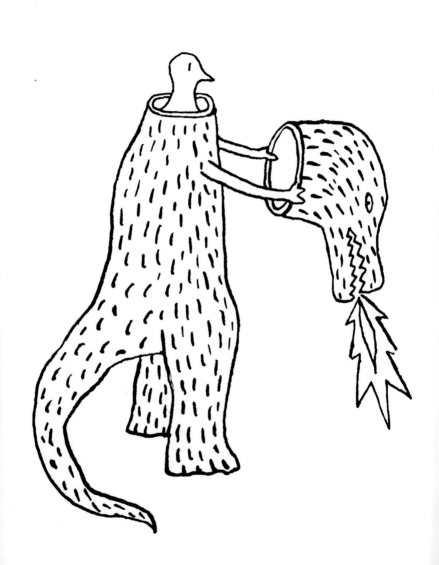

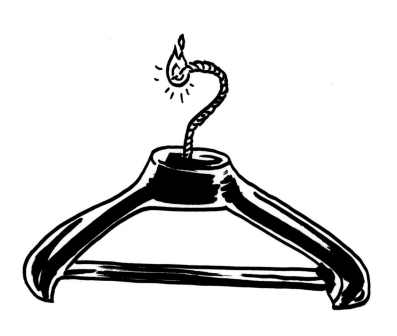

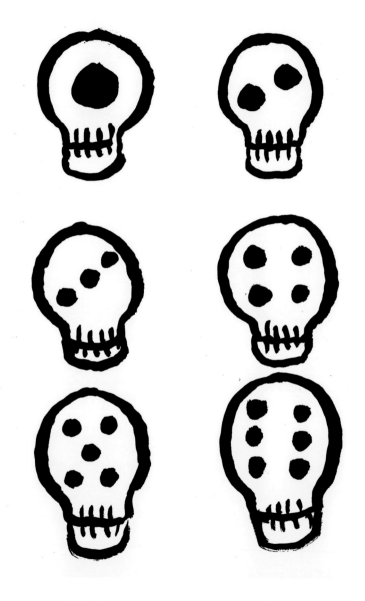

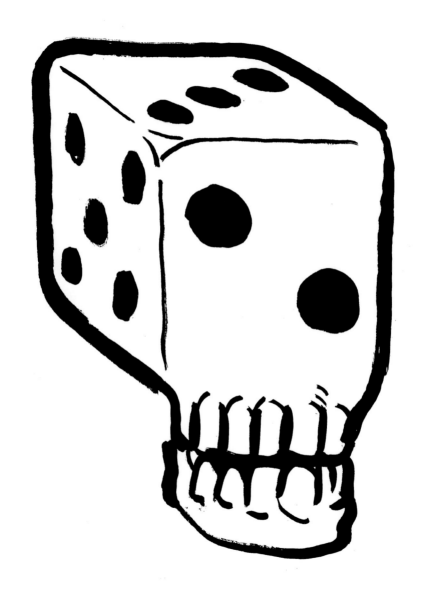

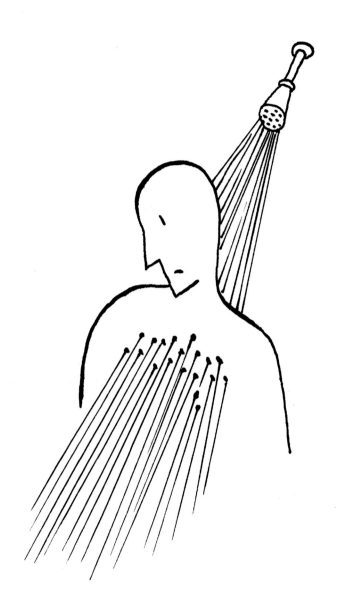

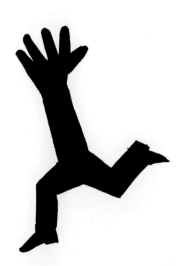

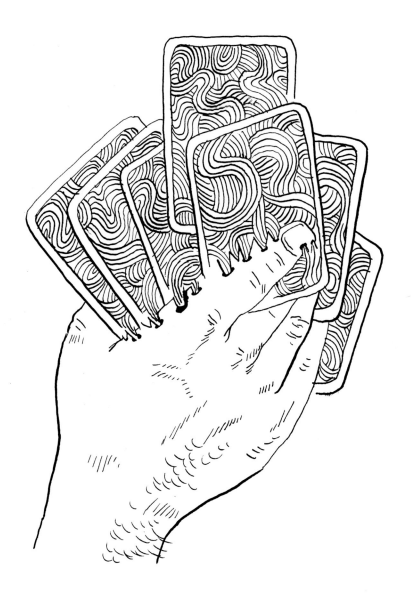

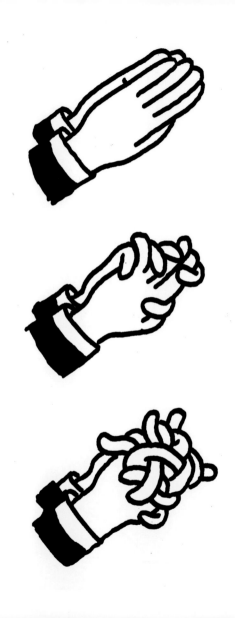

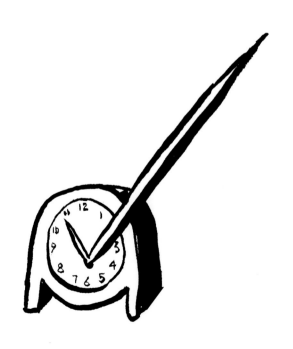

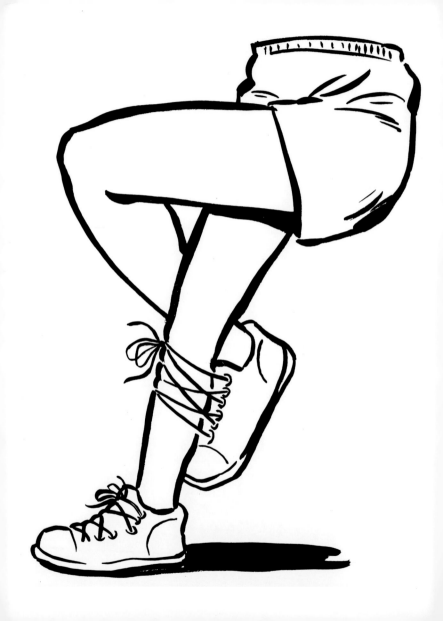

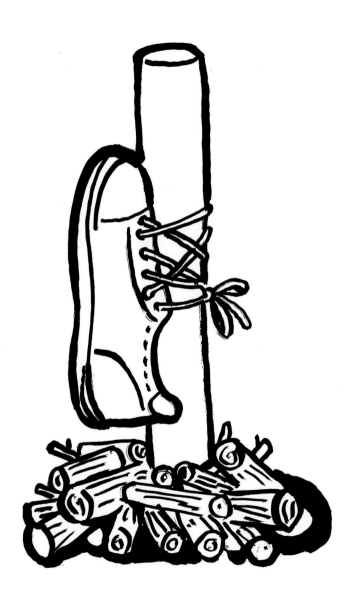

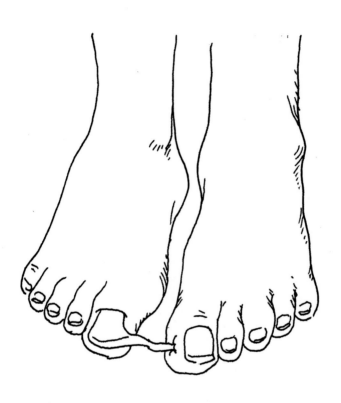

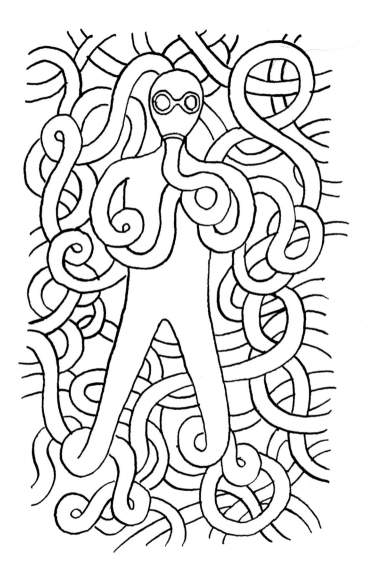

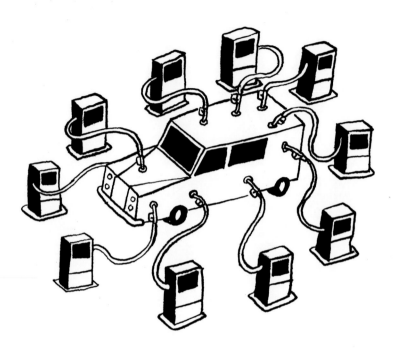

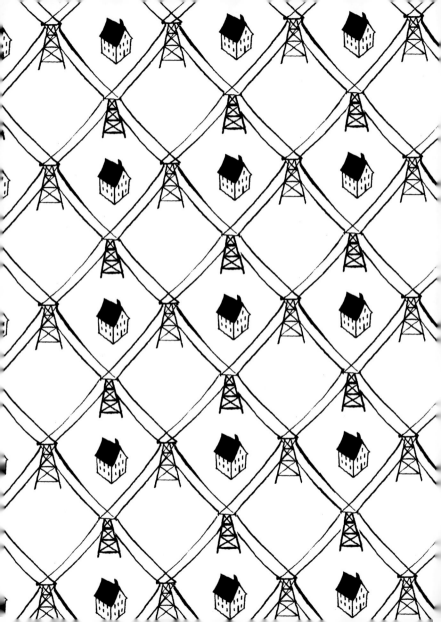

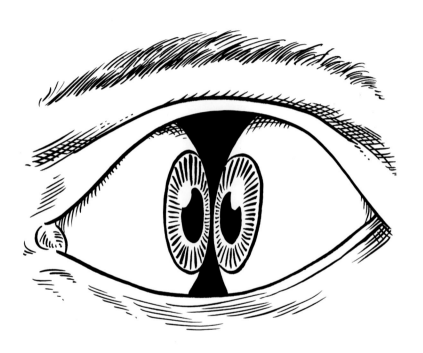

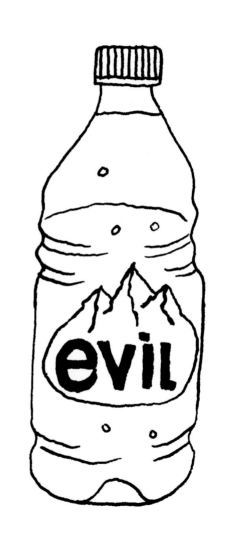

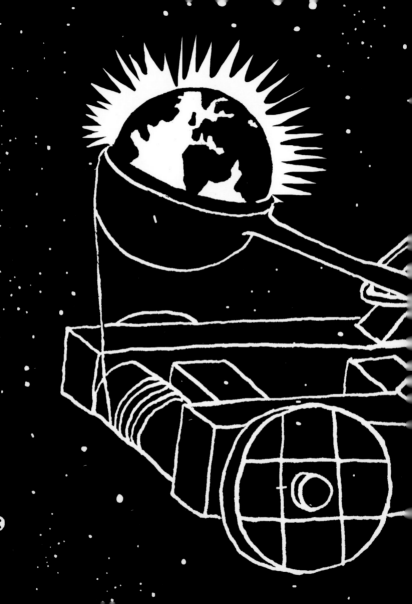

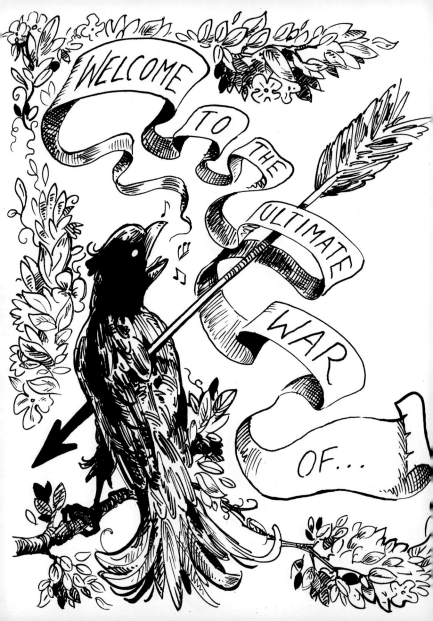

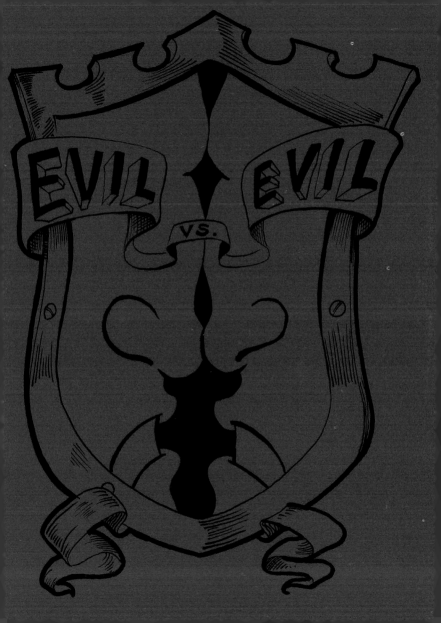

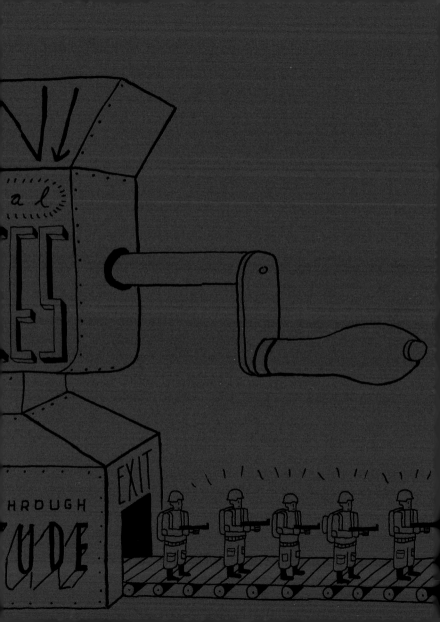

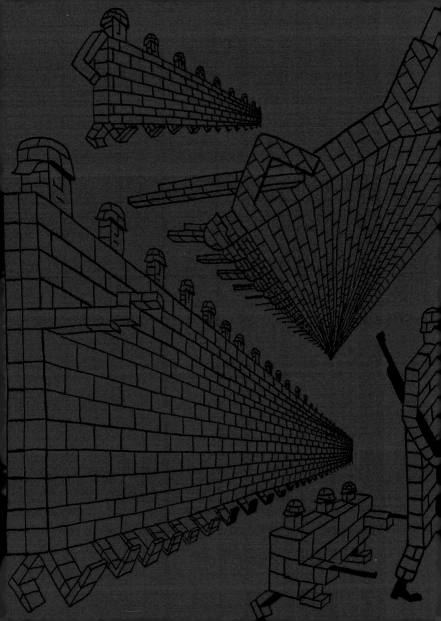

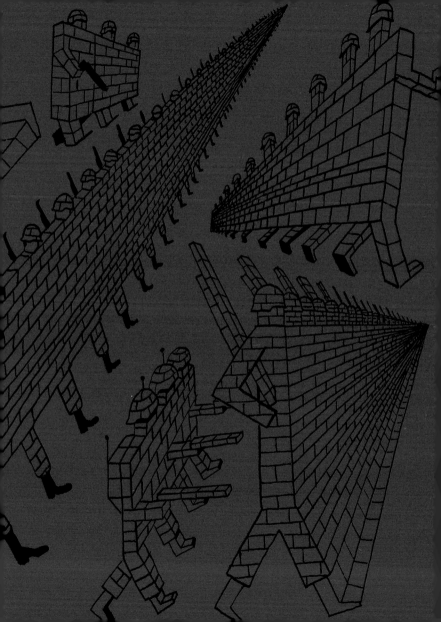

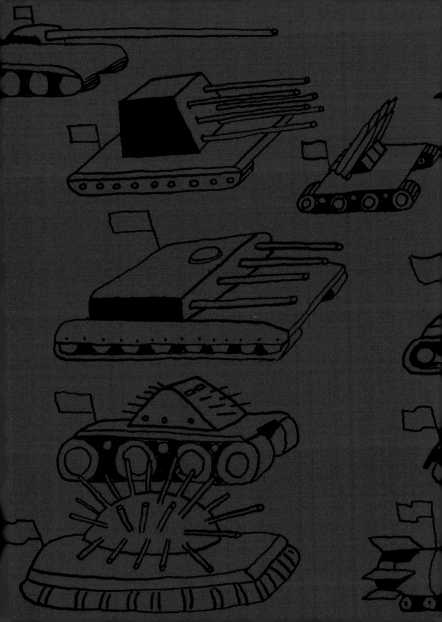

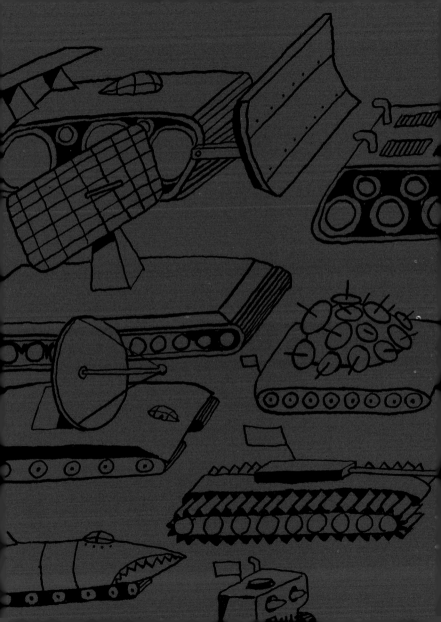

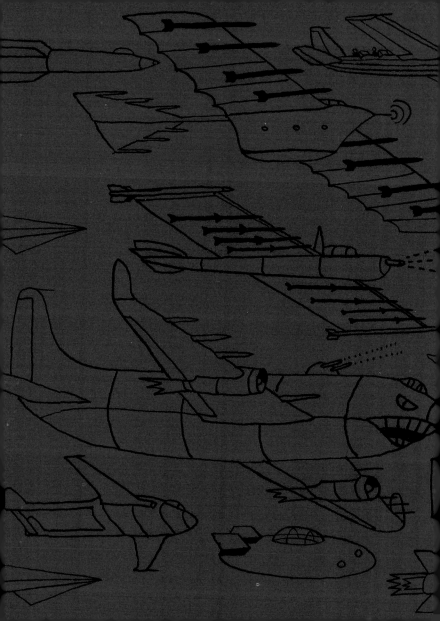

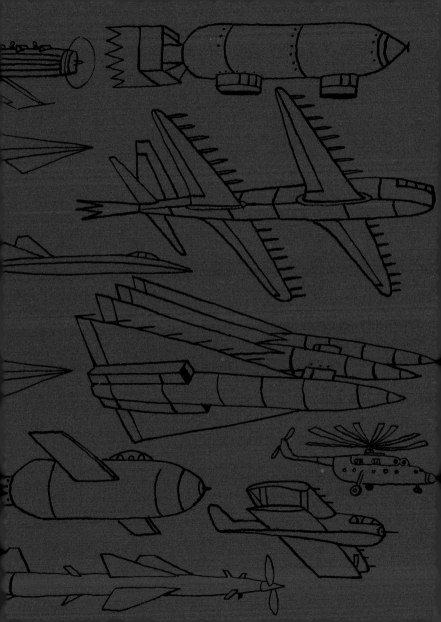

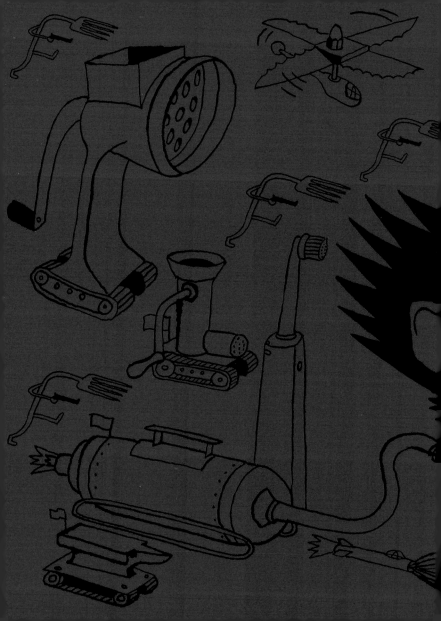

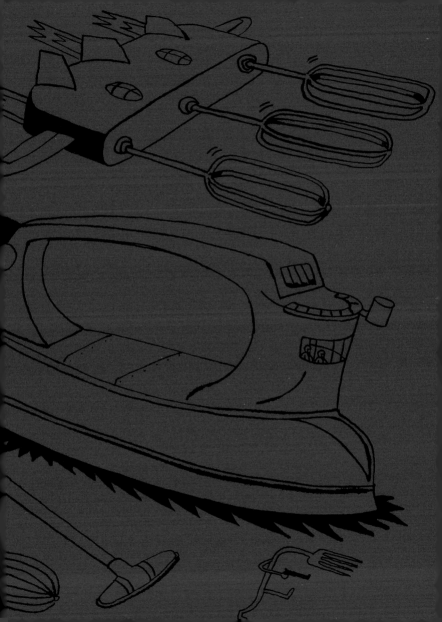

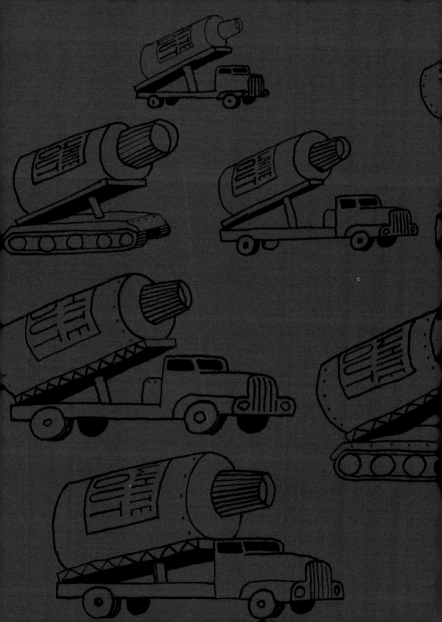

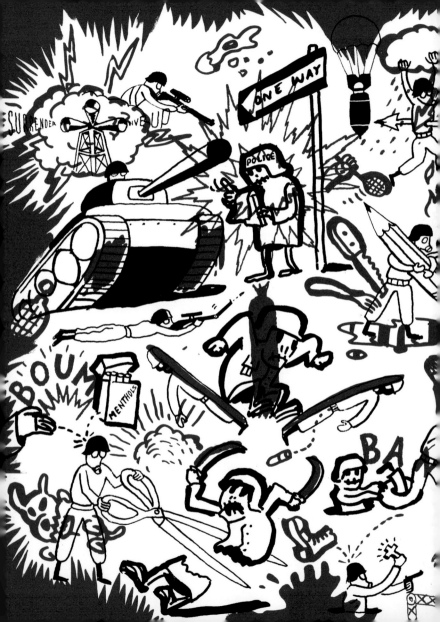

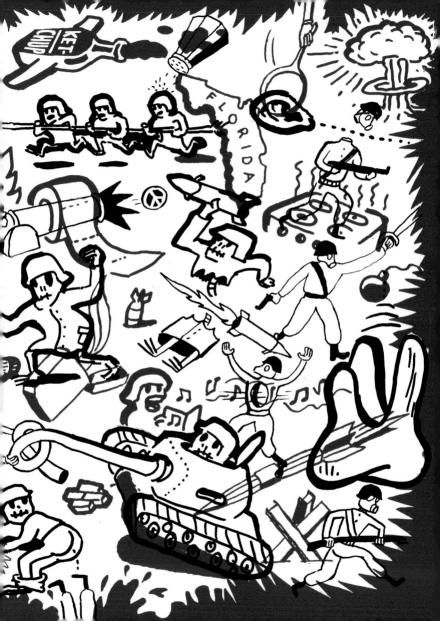

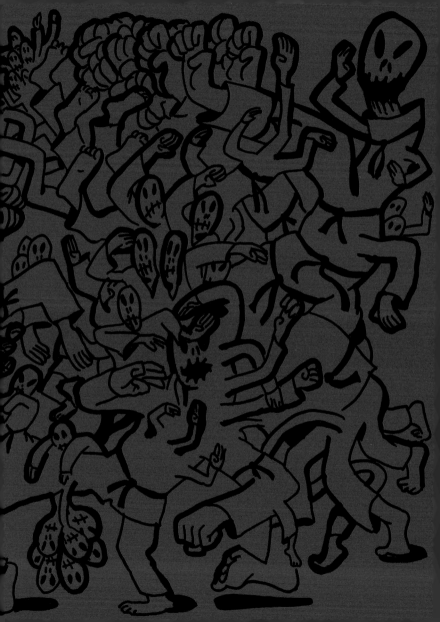

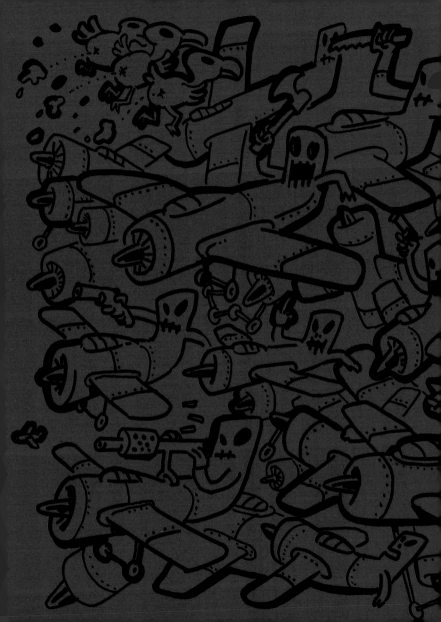

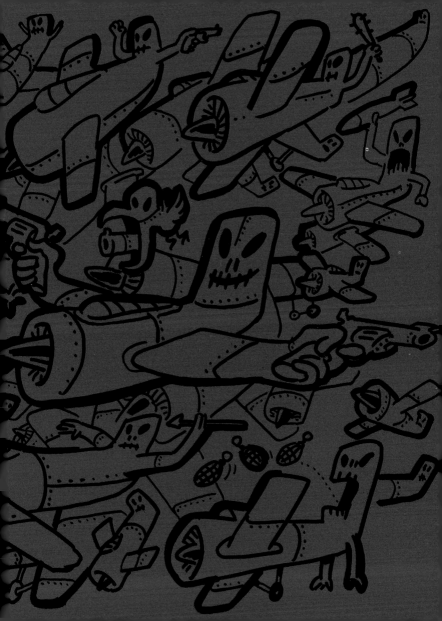

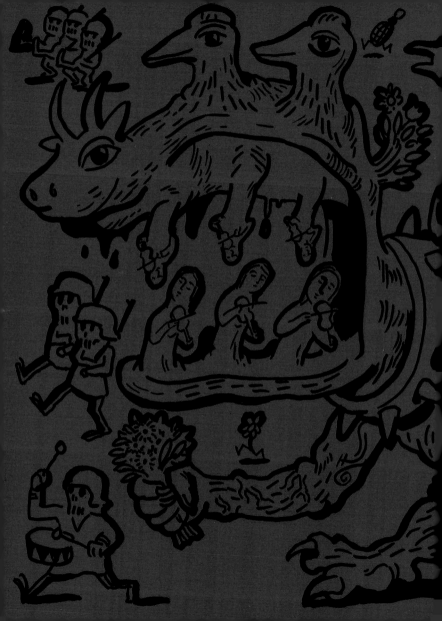

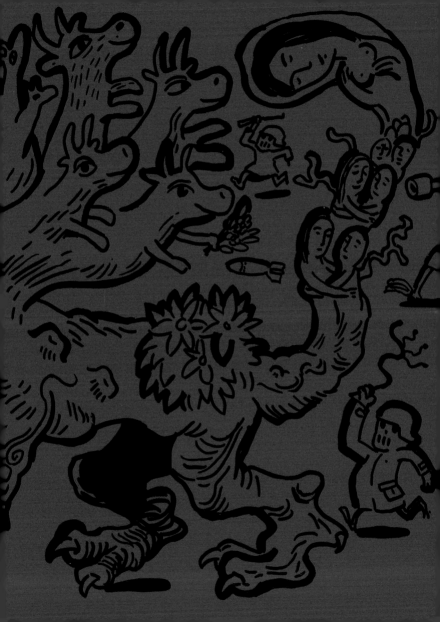

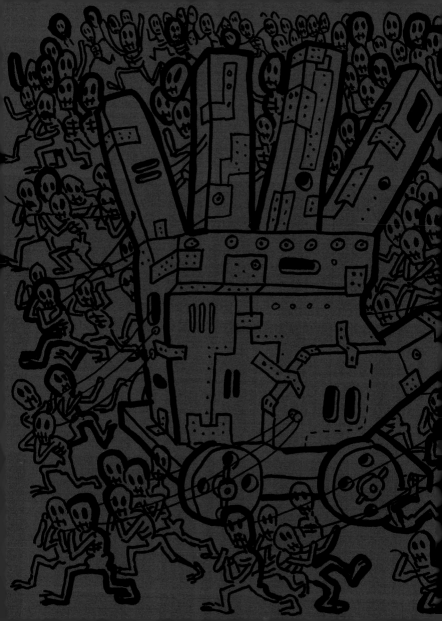

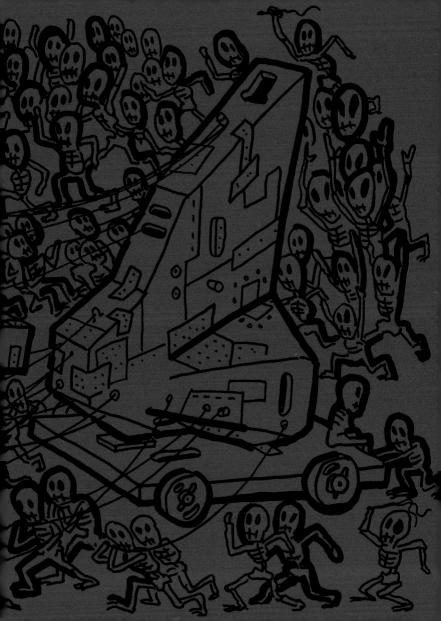

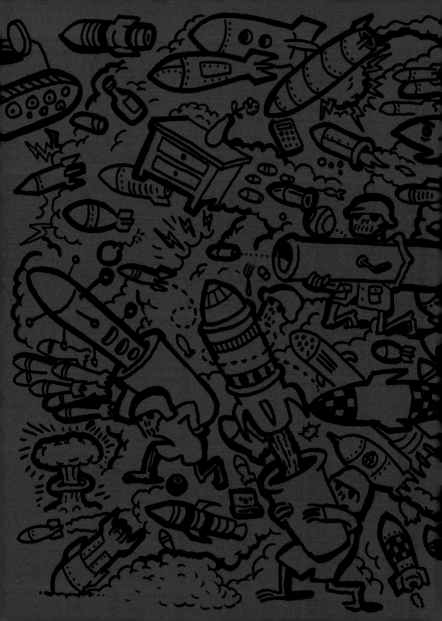

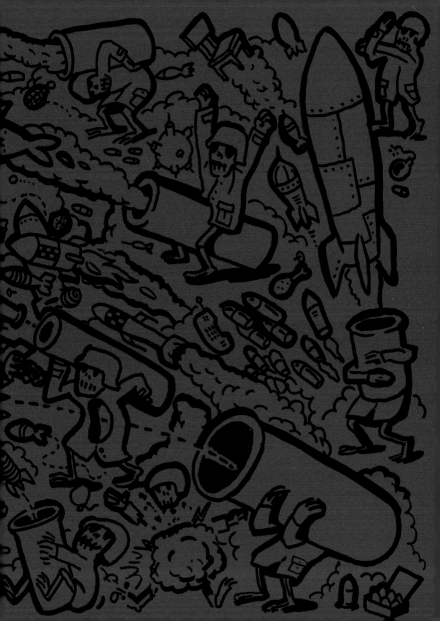

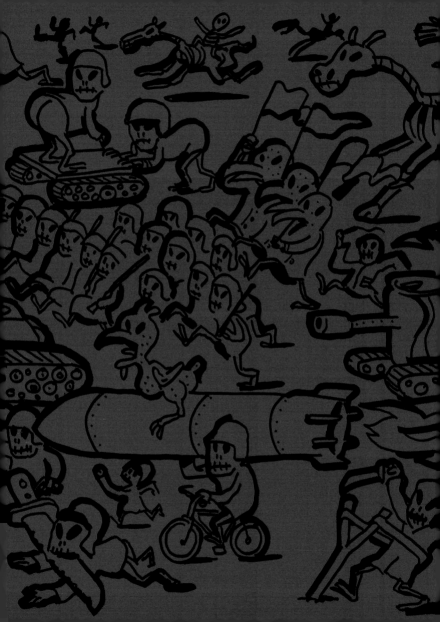

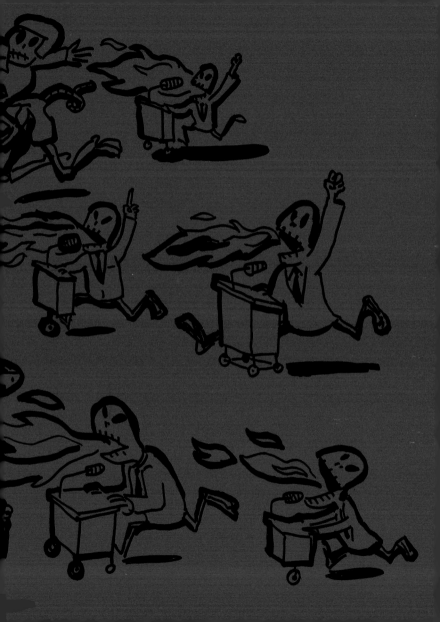

WAR Index

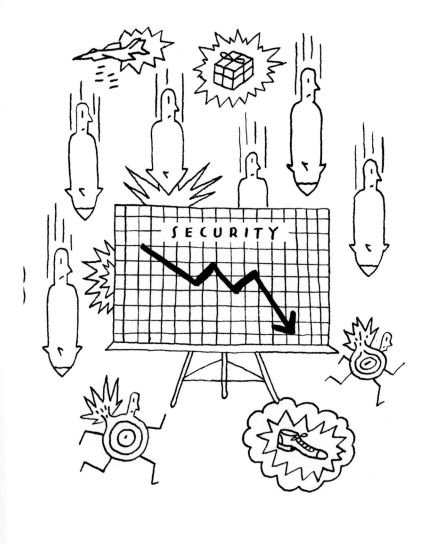

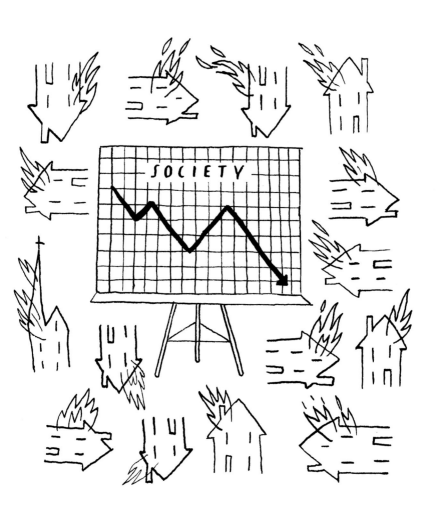

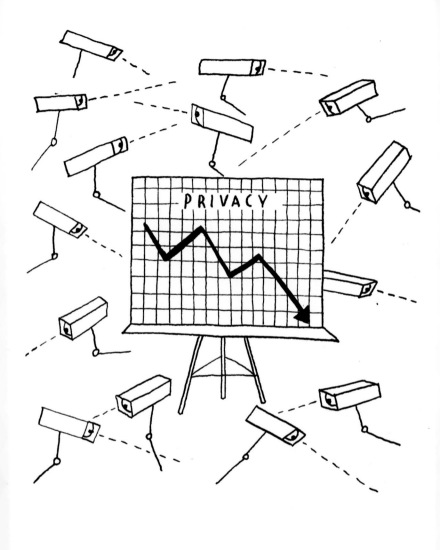

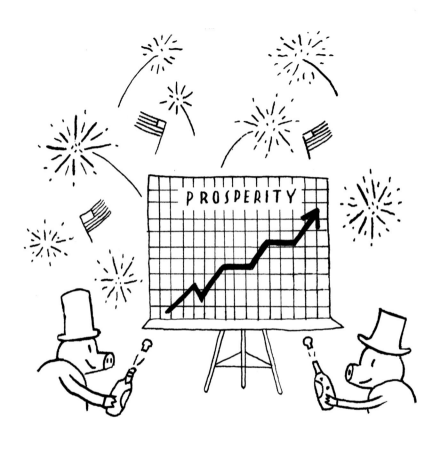

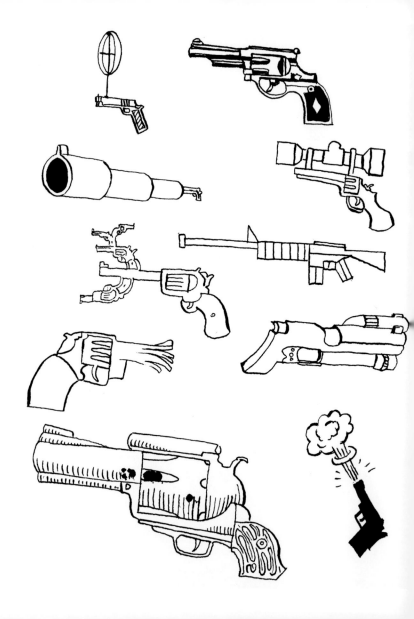

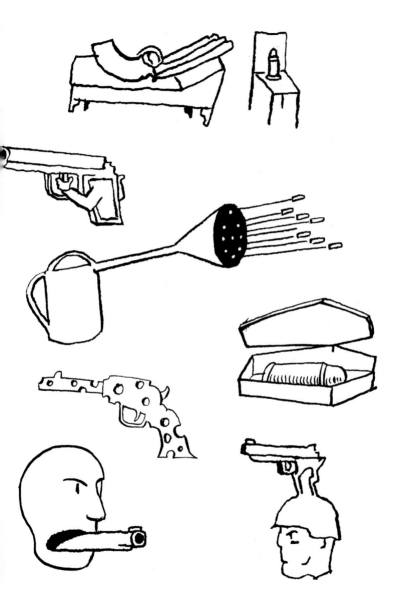

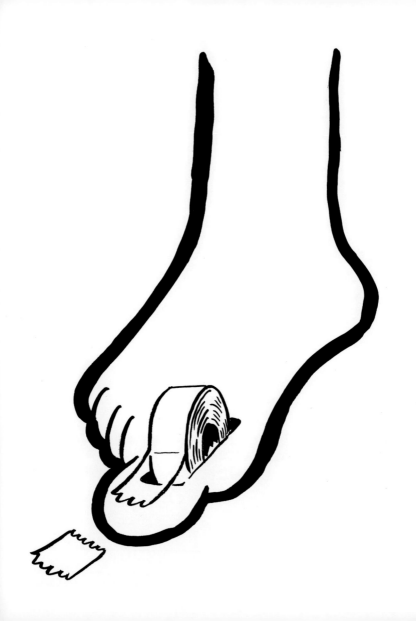

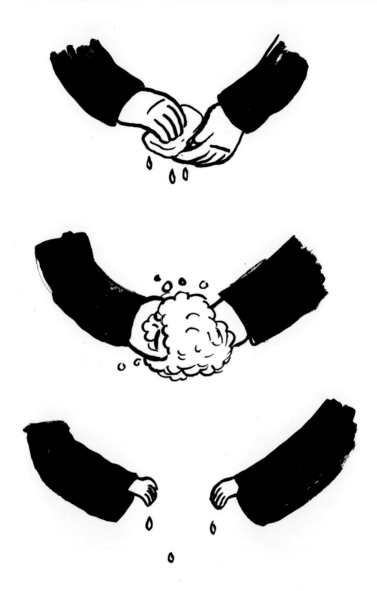

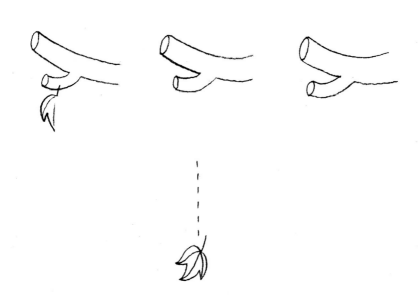

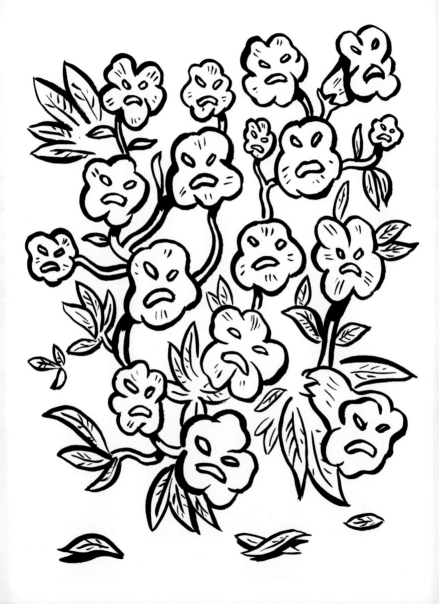

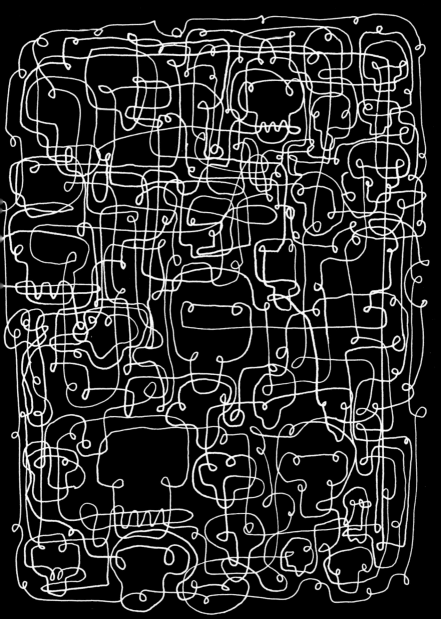

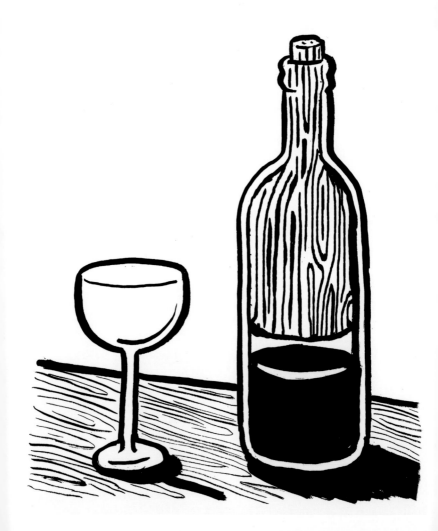

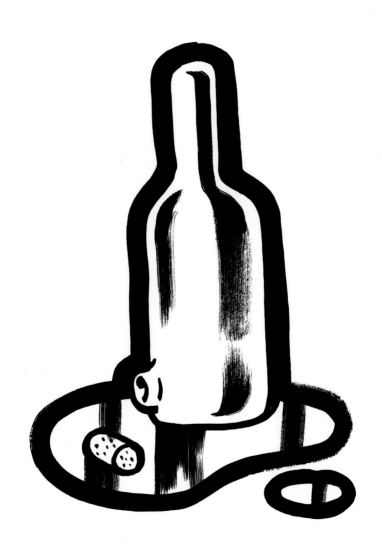

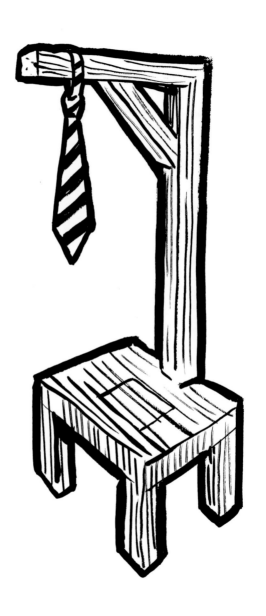

BEWARE

OF THOSE WHO SEE LIFE IN TERMS OF:

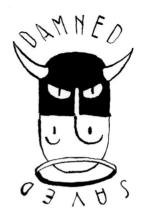

DAMNED / SAVED

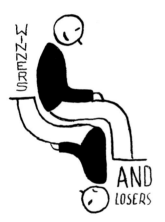

WINNERS AND LOSERS

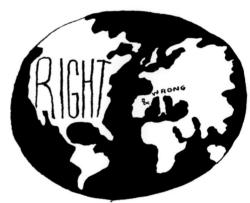

RIGHT & WRONG

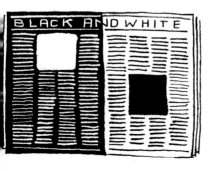

BLACK AND WHITE

GOOD

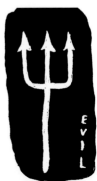

EVIL

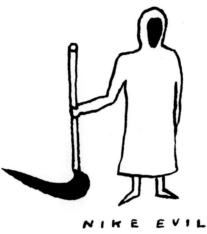

NIKE EVIL

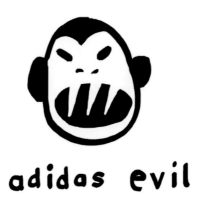

adidas evil

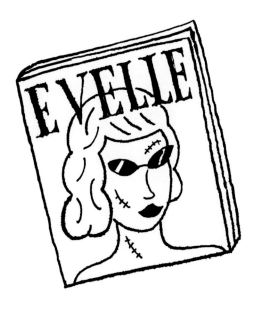

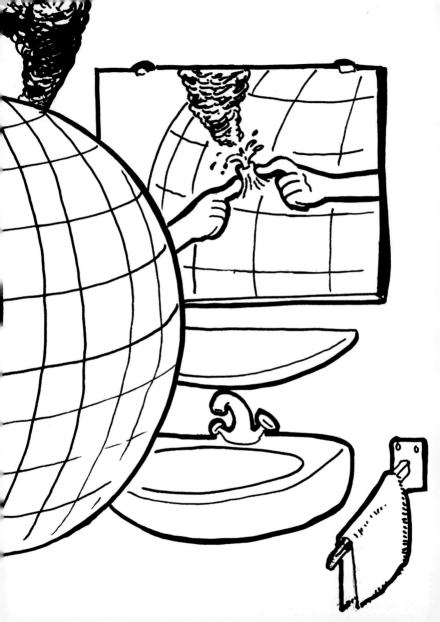

SEMI-EVIL

SATAN'S CAR

THANKS TO

Paul Sahre, everybody in room #309, especially Naomi, Lia, and Chika. Thanks to
Aviva for her design assistance and R.O. Blechman for his comments.
Thanks to Luise for being the antithesis of evil 100% of the time. Thanks to Lisa for
her eyes, ears, and heart. Thanks to Clare Jacobson for her editorial wisdom
and to Kevin Lippert for publishing our work.

Special thanks to Chip Kidd.

This is 13% of 100%. Previous volumes were printed in editions of 100 copies,
signed and numbered. The first printing of this volume has been published in an
edition of 3000. The theme for this issue is "EVIL."

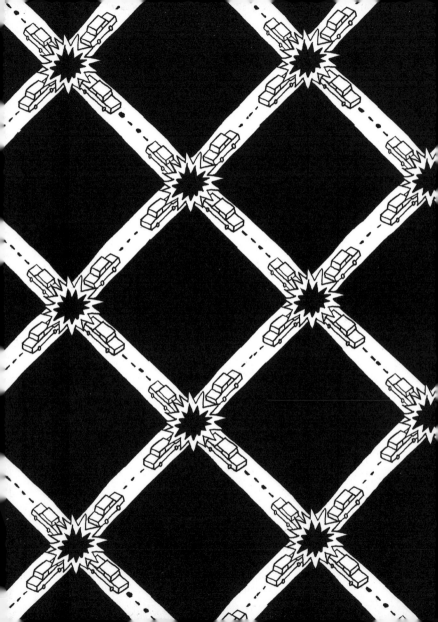